Fanciful Sea Life

COLORING BOOK

Marjorie Sarnat

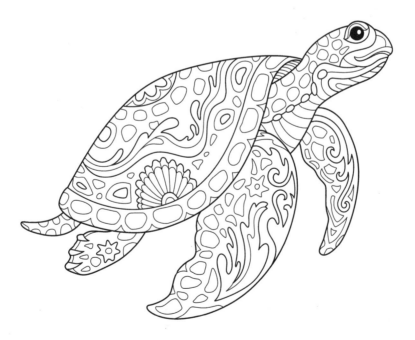

DOVER PUBLICATIONS, INC.
MINEOLA, NEW YORK

Imagine the calmness and serenity of taking an underwater adventure as you add color to the 31 enthralling designs that make up this unique sea life collection. Intended for advanced colorists, the illustrations feature a variety of fish and sea inhabitants—some real and some imagined—such as angelfish, penguins, starfish, sea turtles, whales, a family of walruses, a mother and baby whale adorned with whimsical markings, and even mermaids! Mesmerizing aquatic backgrounds complete the decorative sea life tableaus. After coloring with your choice of media, remove the perforated pages from the book and display your beautiful artwork for everyone to see.

Bibliographical Note

Fanciful Sea Life Coloring Book is a new work, first published by Dover Publications, Inc., in 2018.

International Standard Book Number

ISBN-13: 978-0-486-81858-0
ISBN-10: 0-486-81858-6

Manufactured in the United States by LSC Communications
81858607 2019
www.doverpublications.com

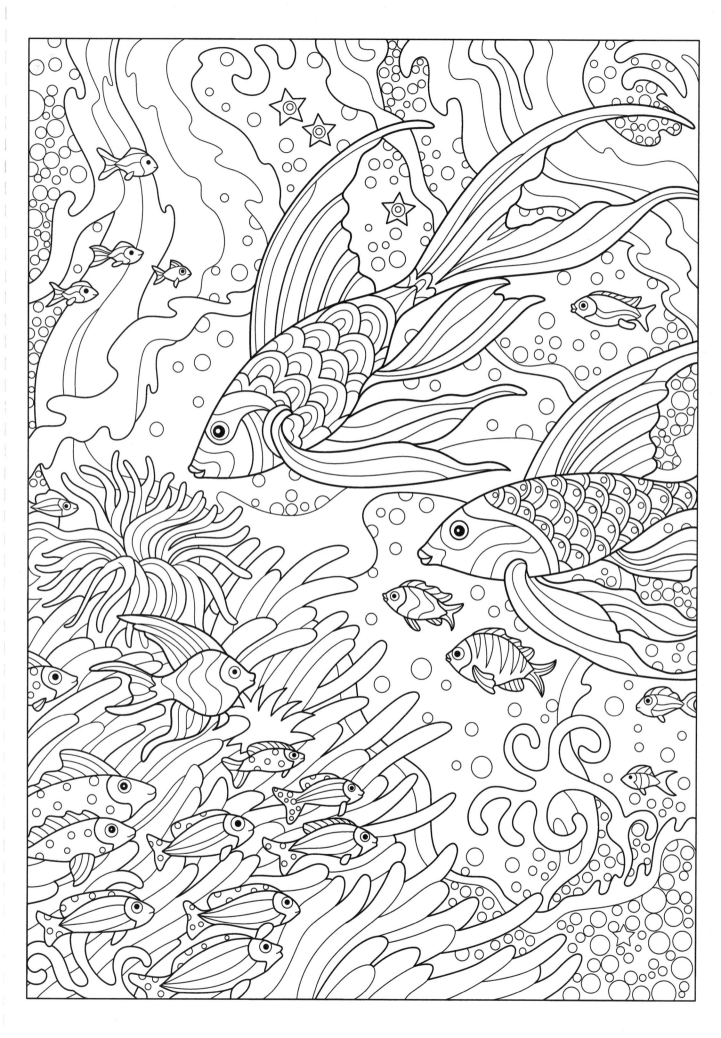

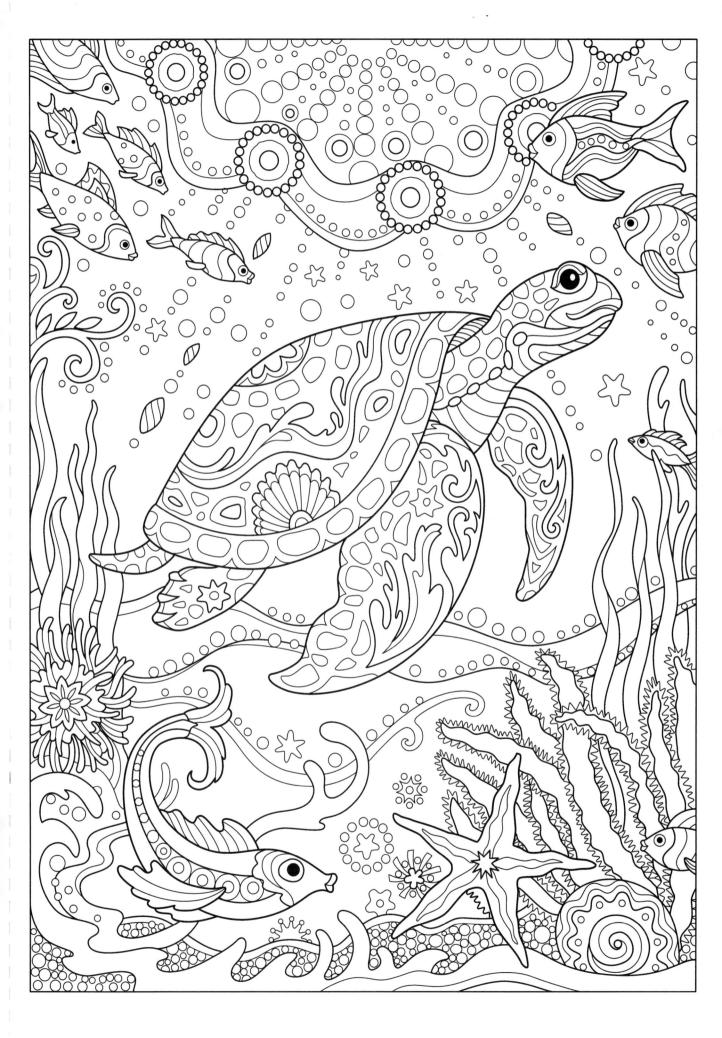

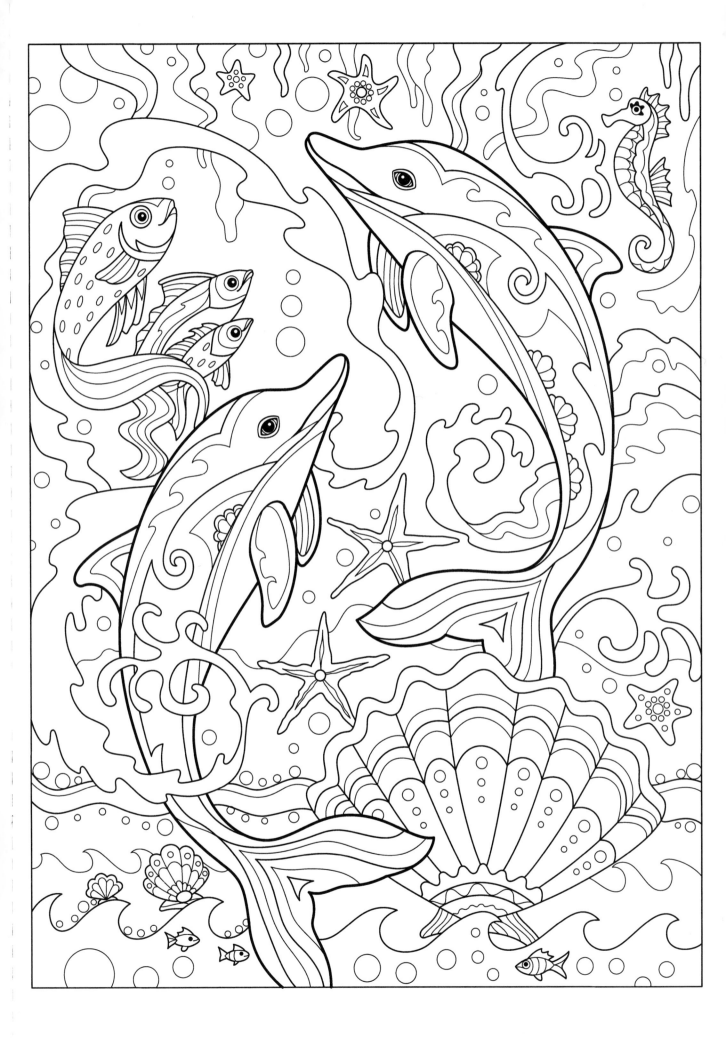

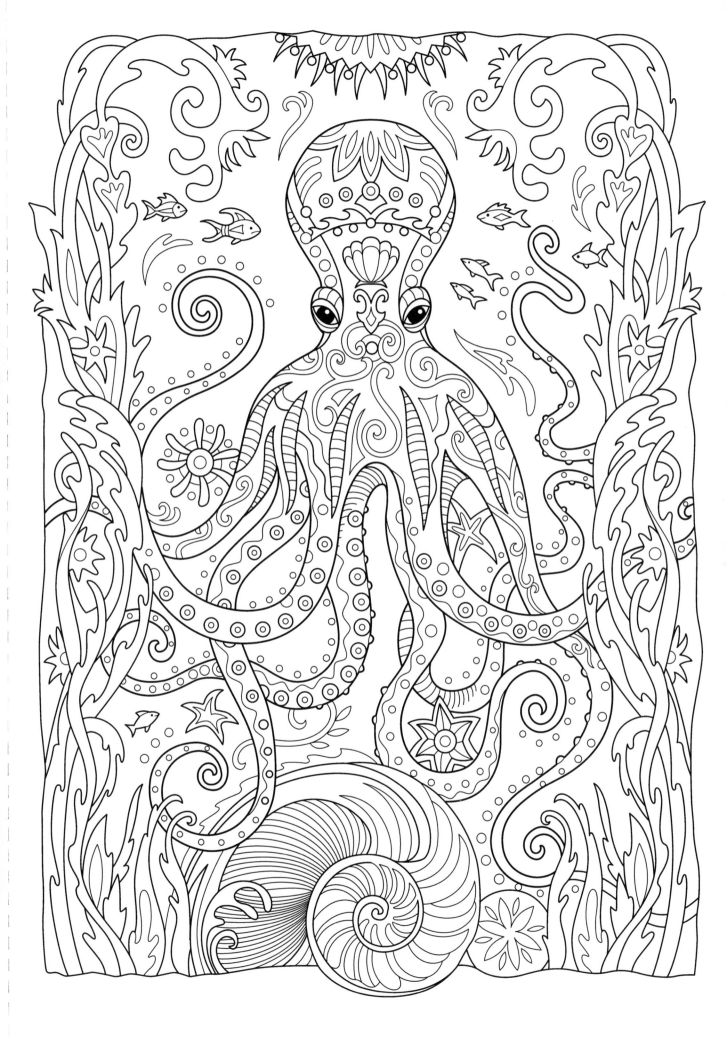

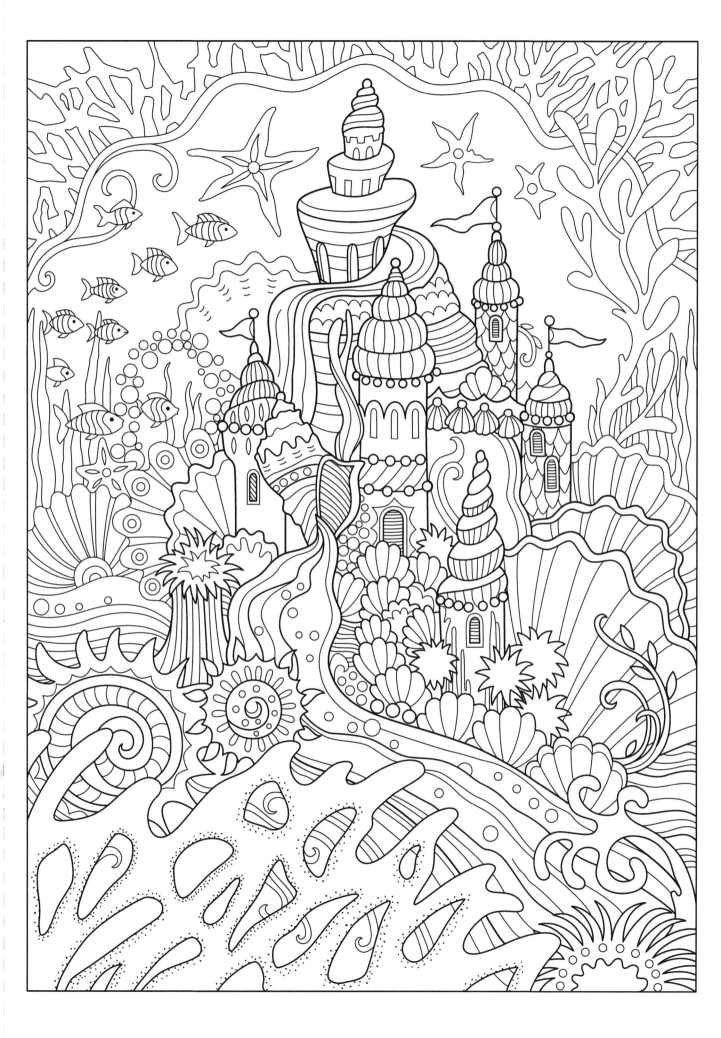

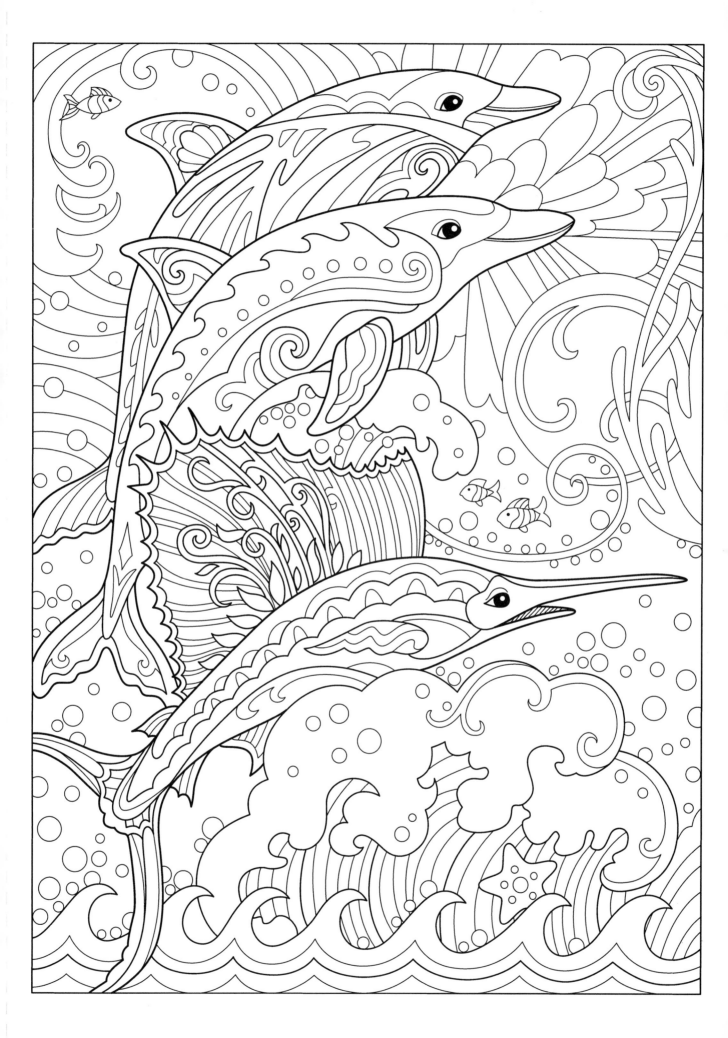

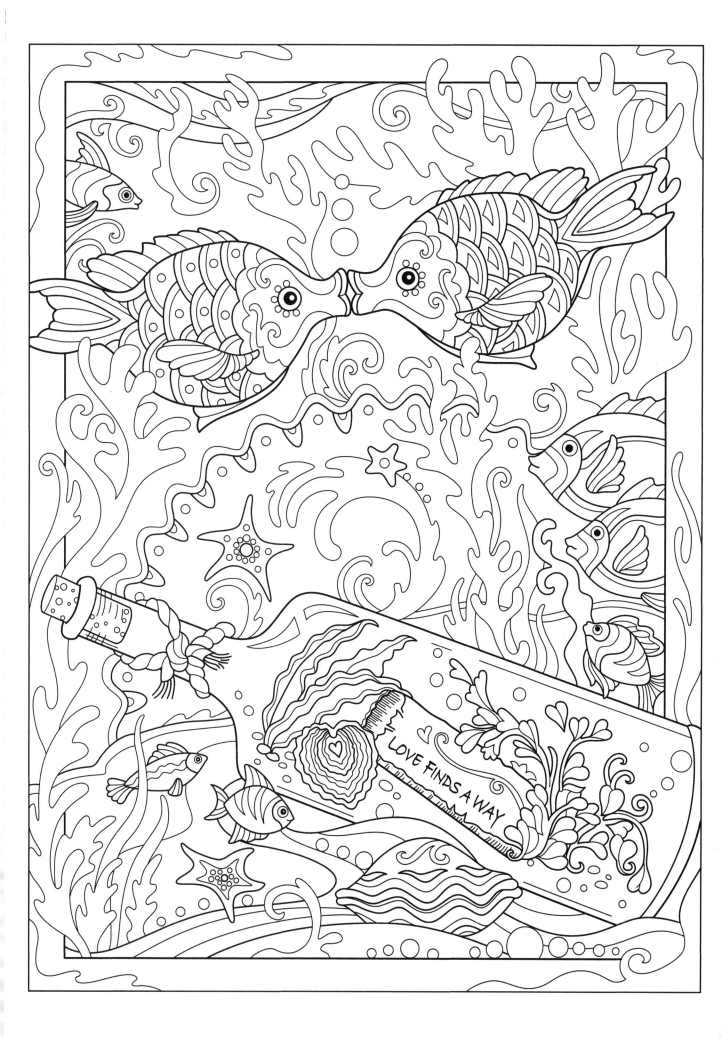

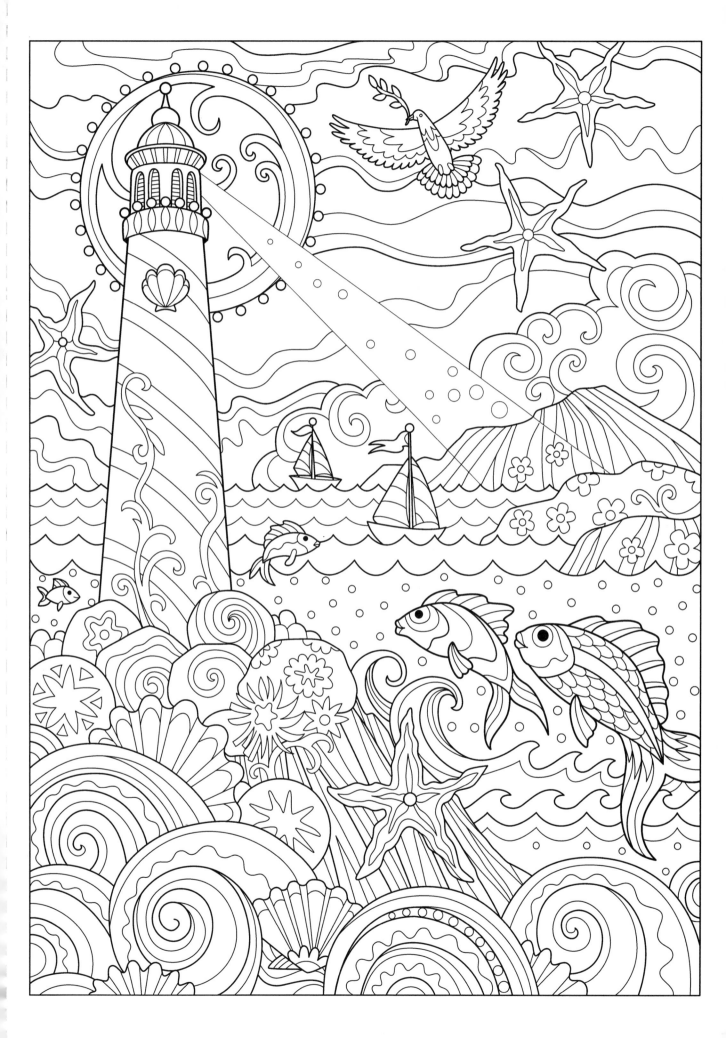

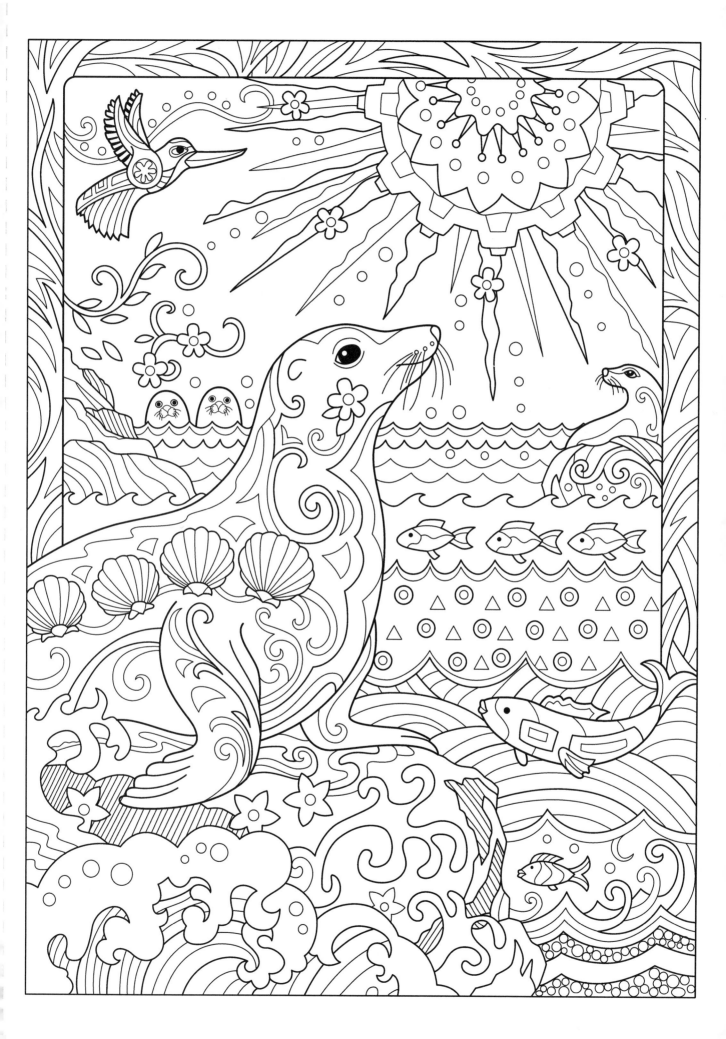

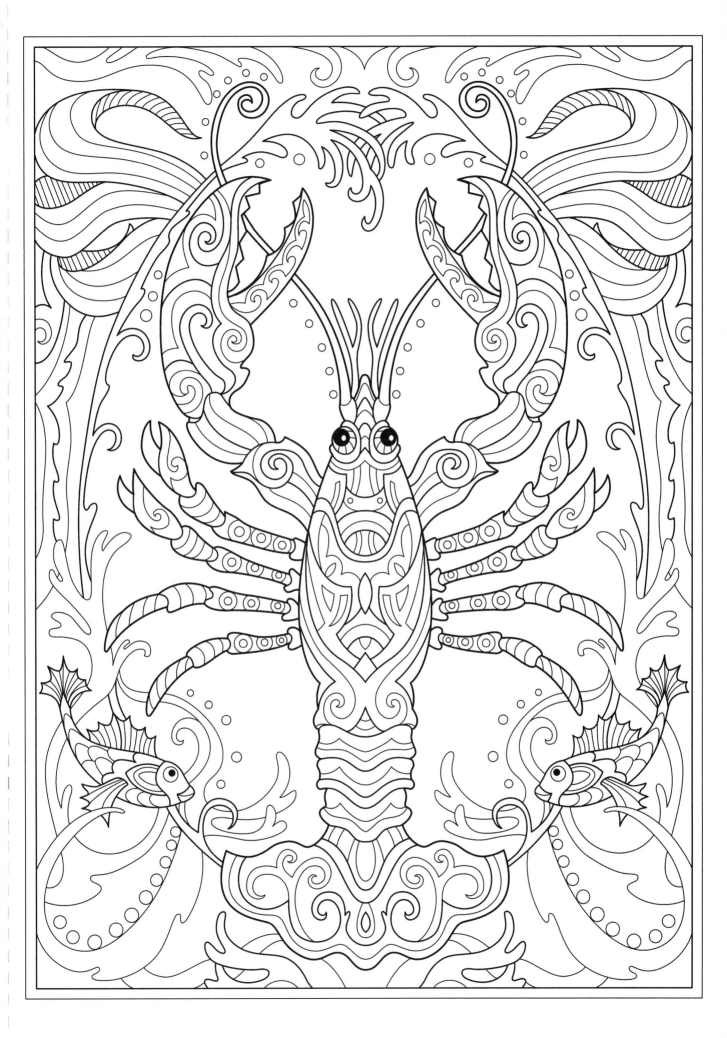

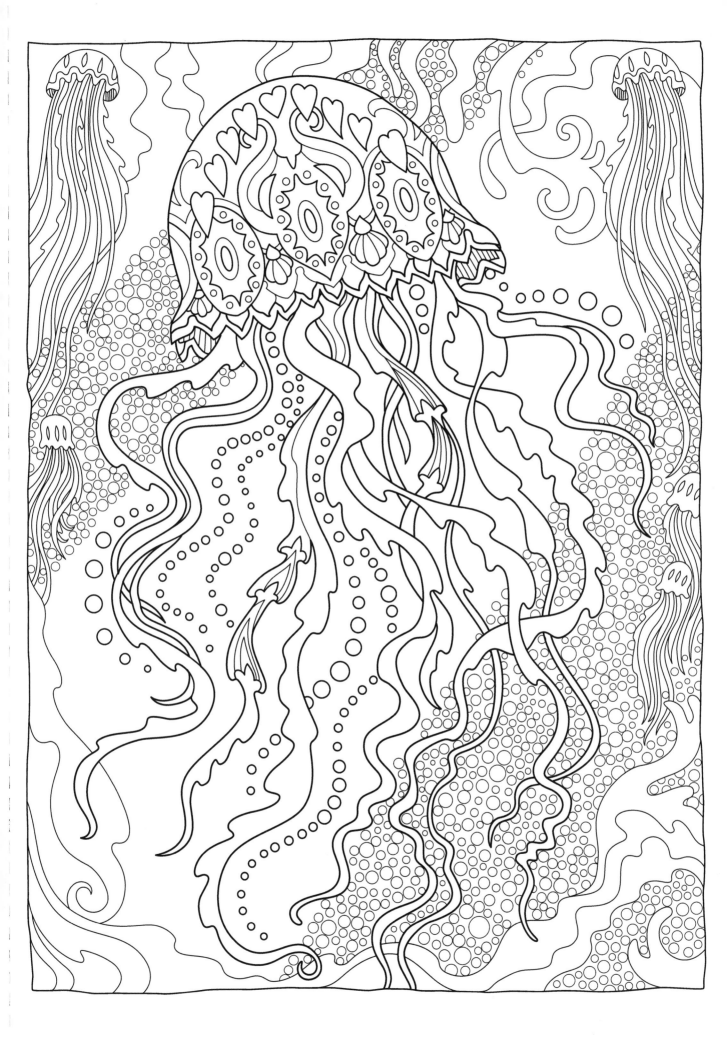

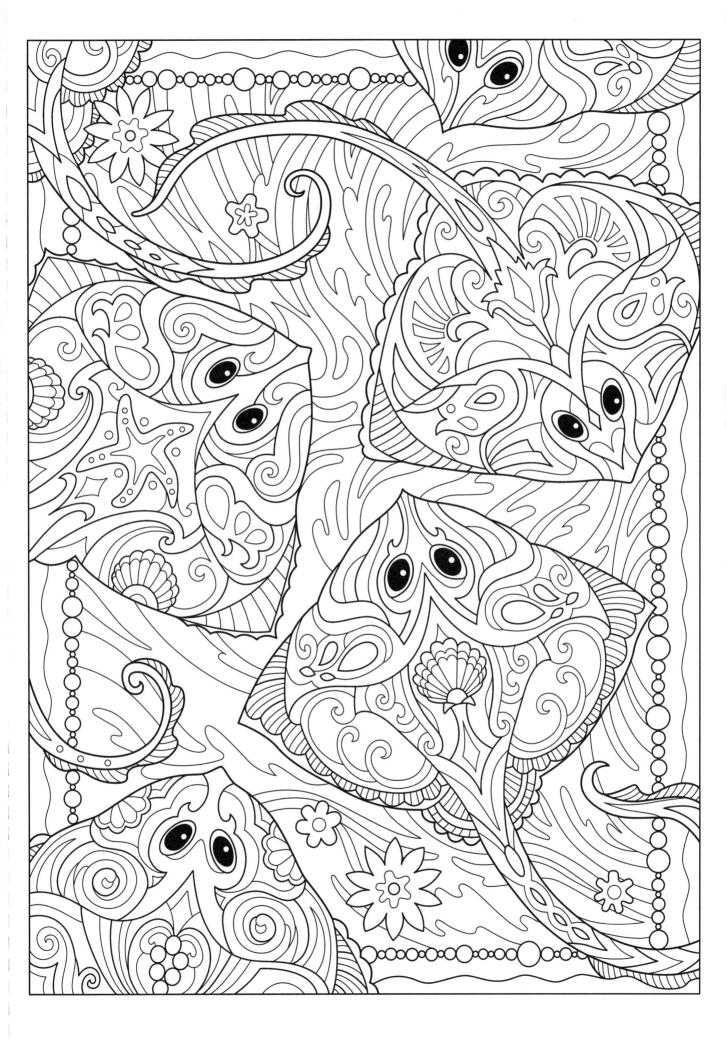

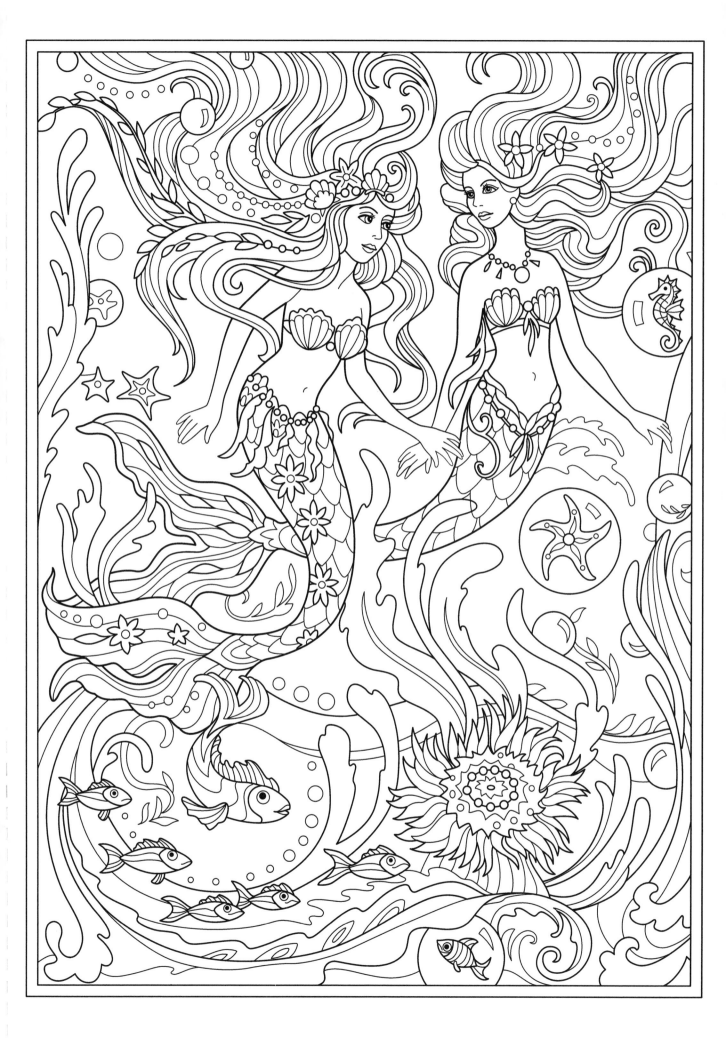

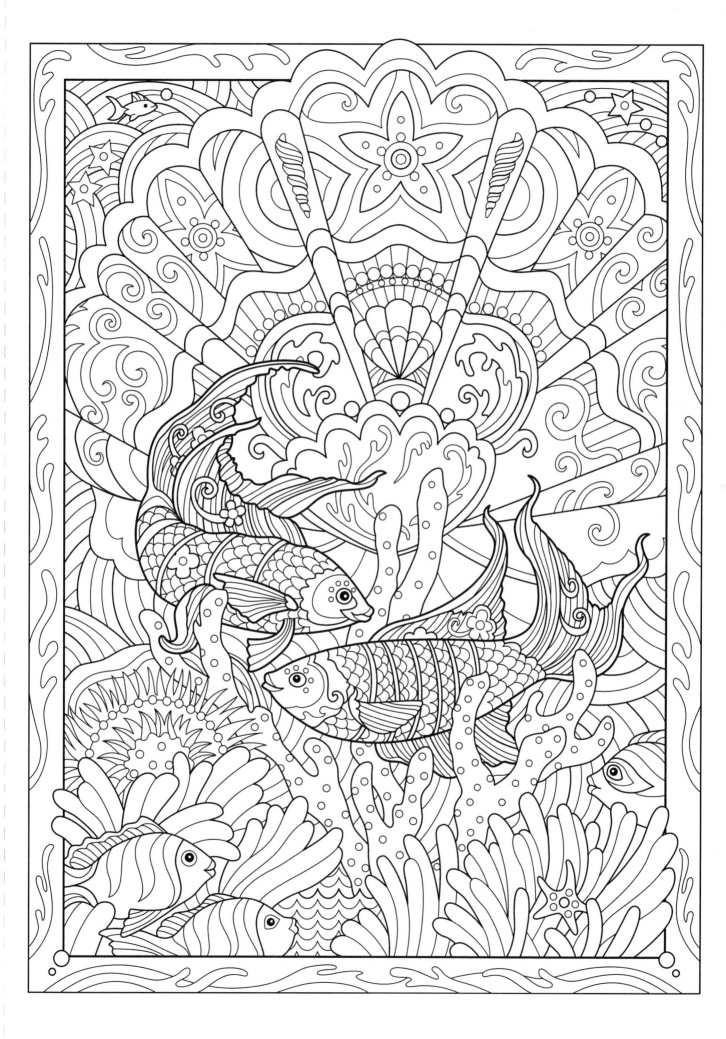

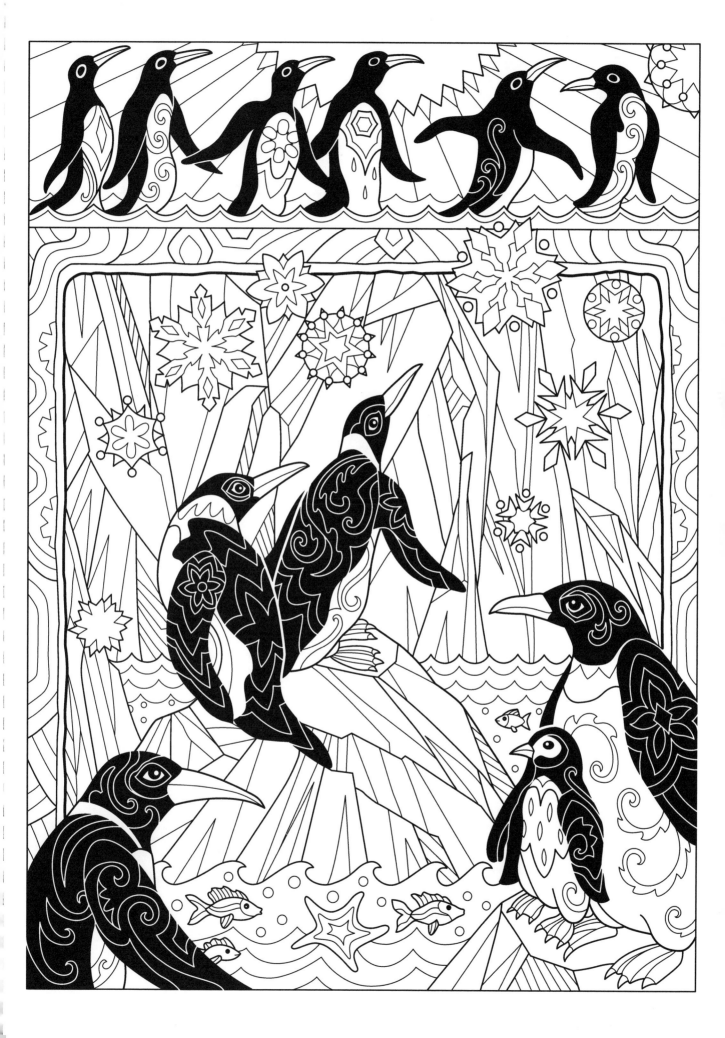

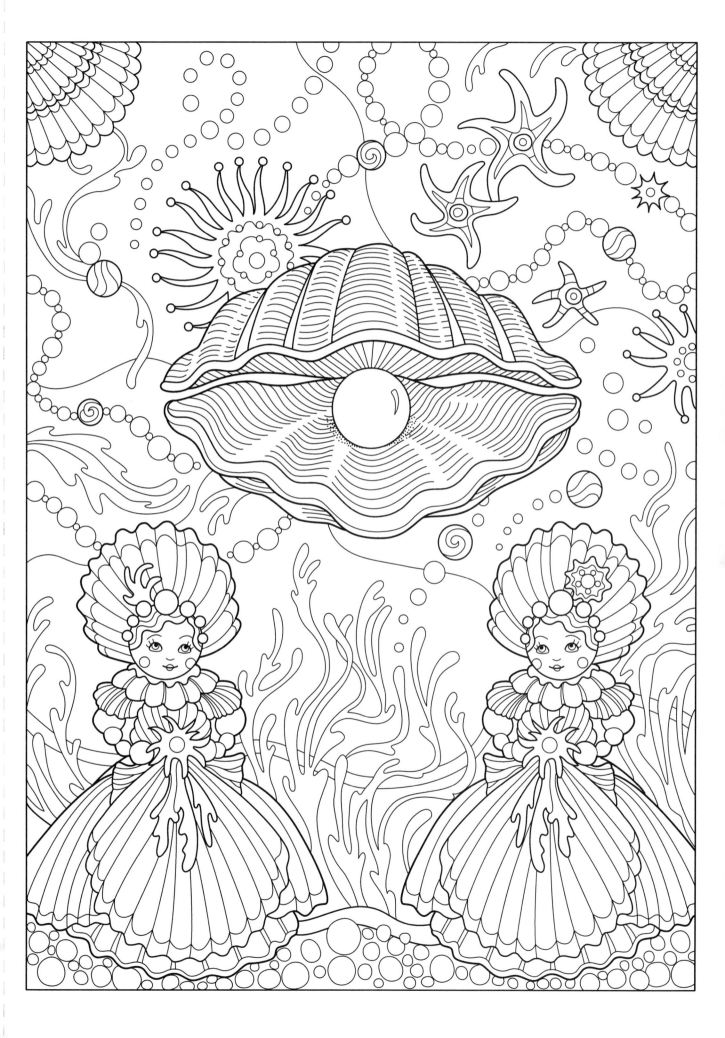

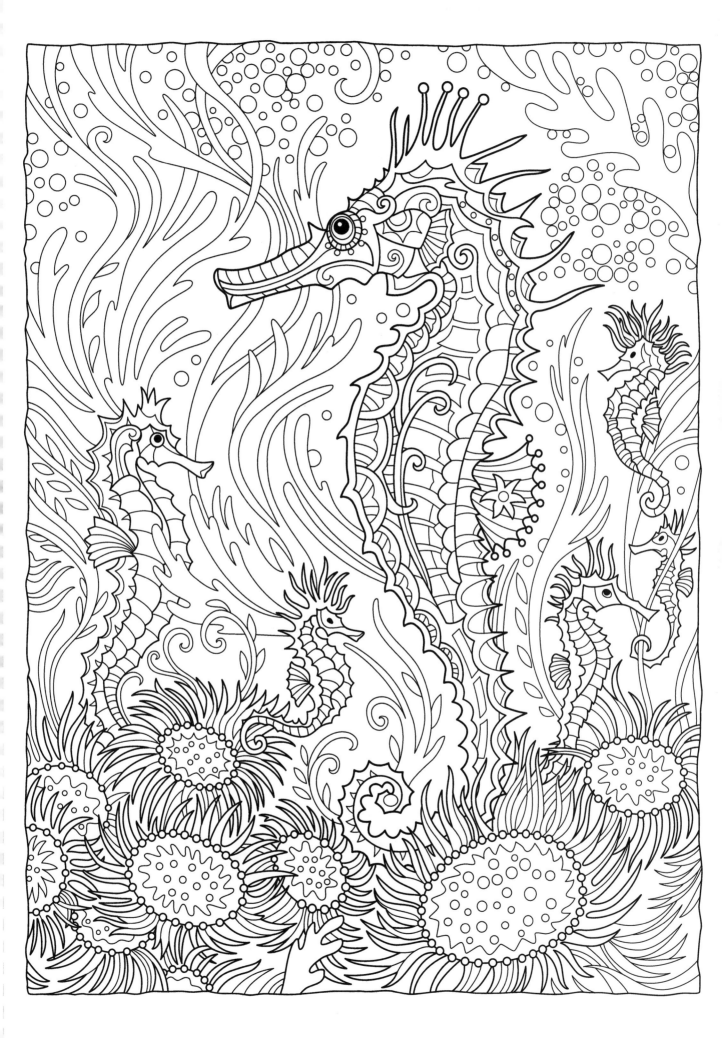

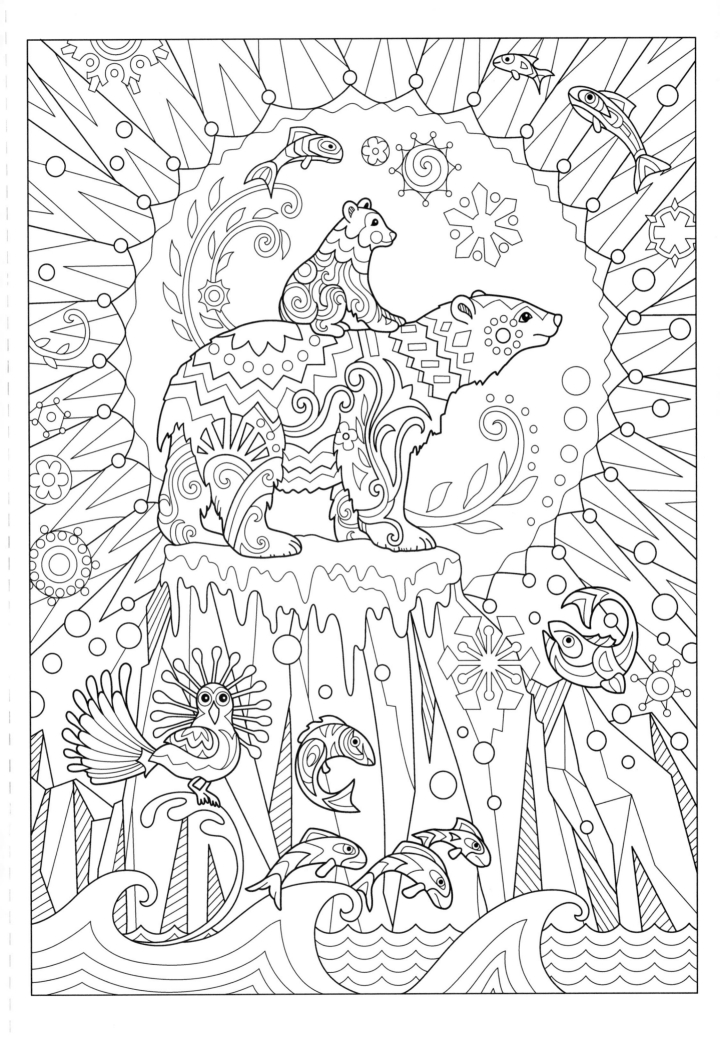

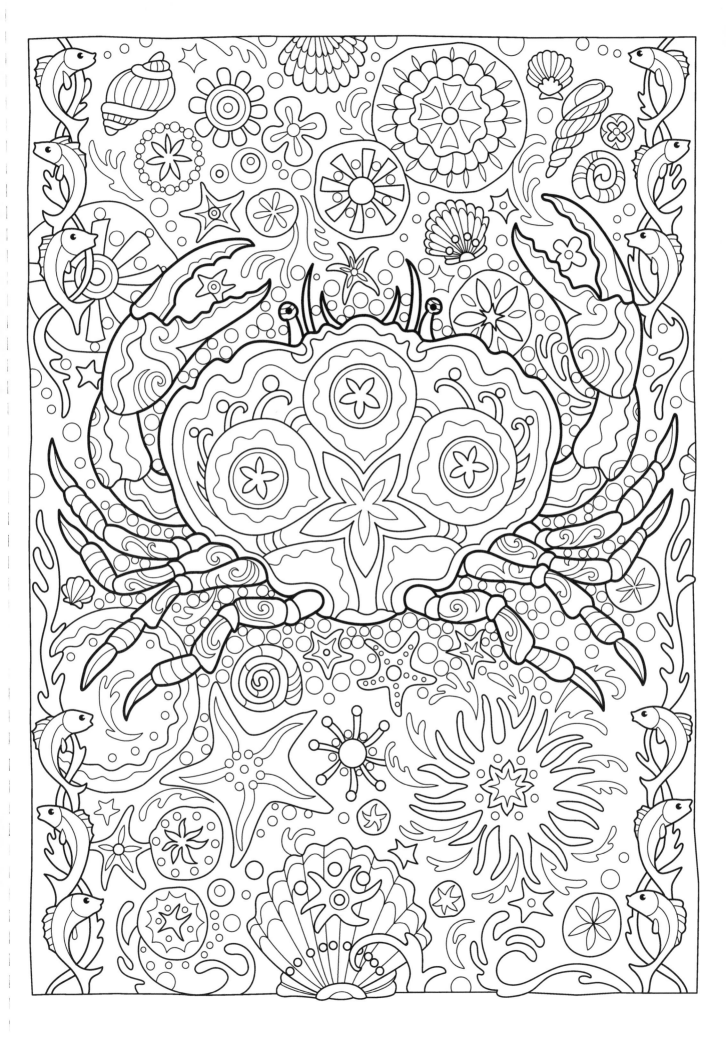

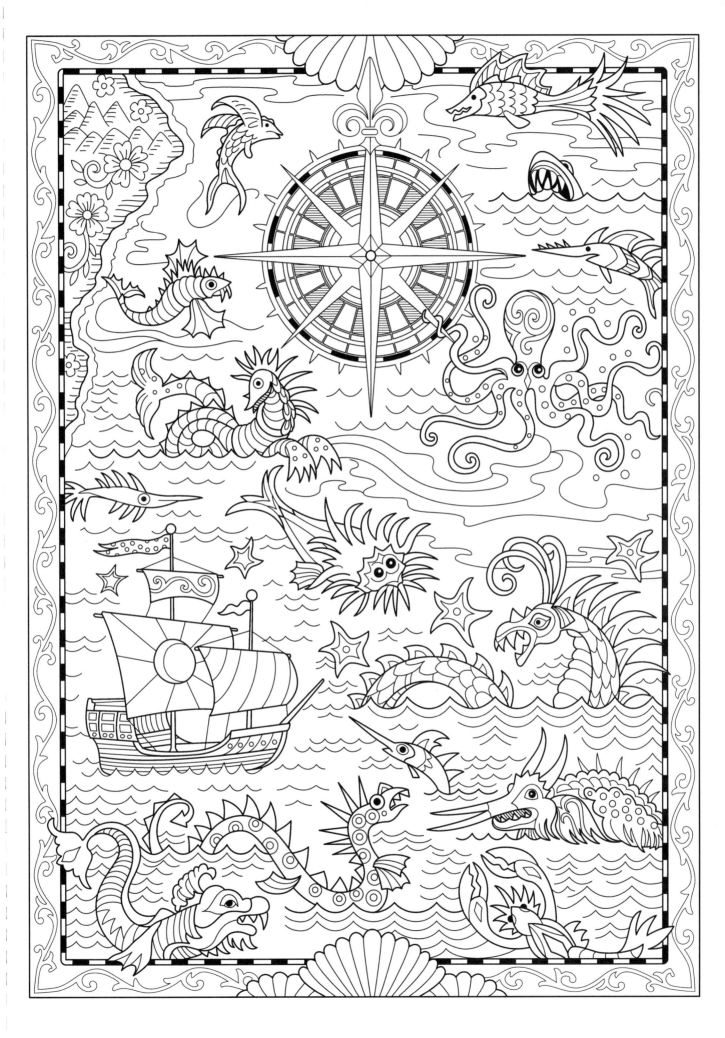

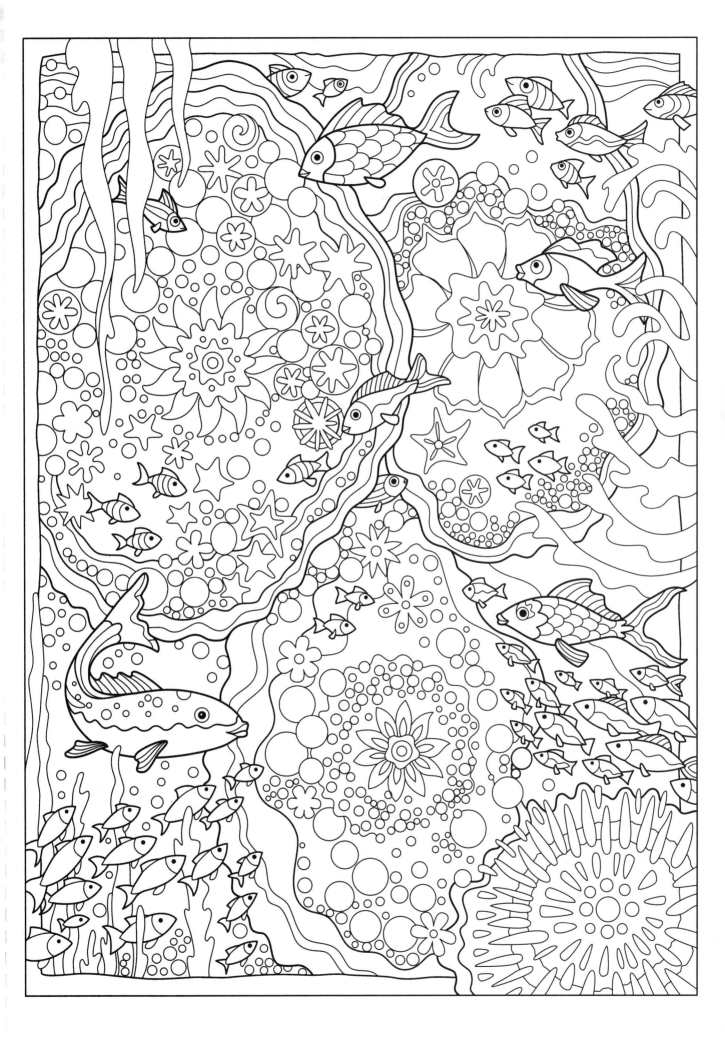

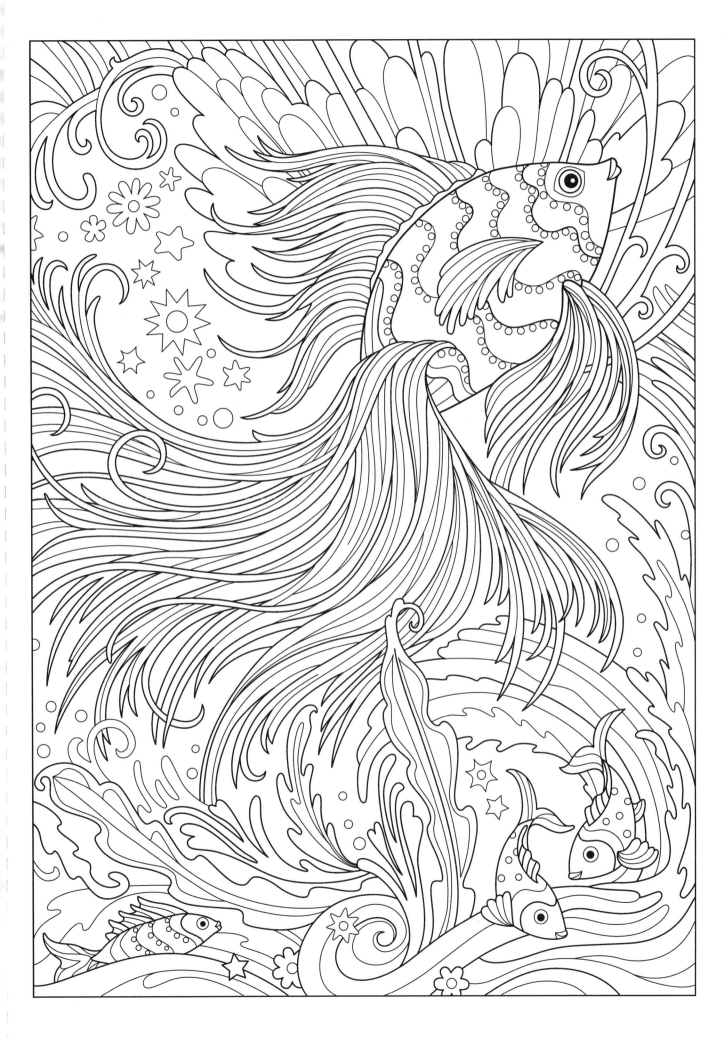

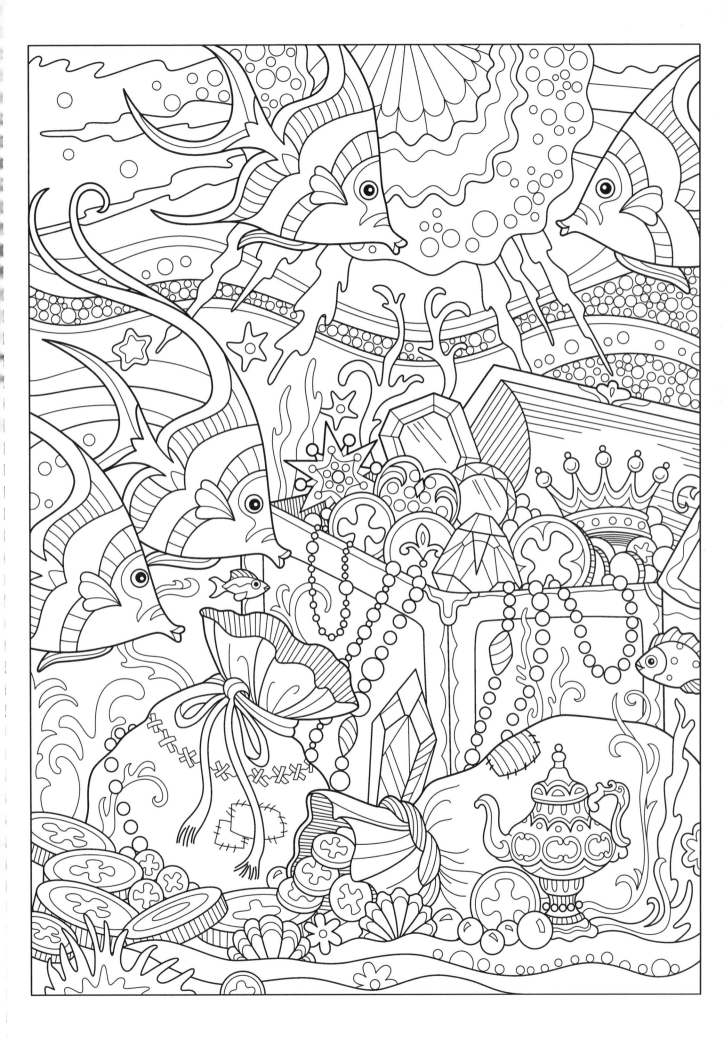

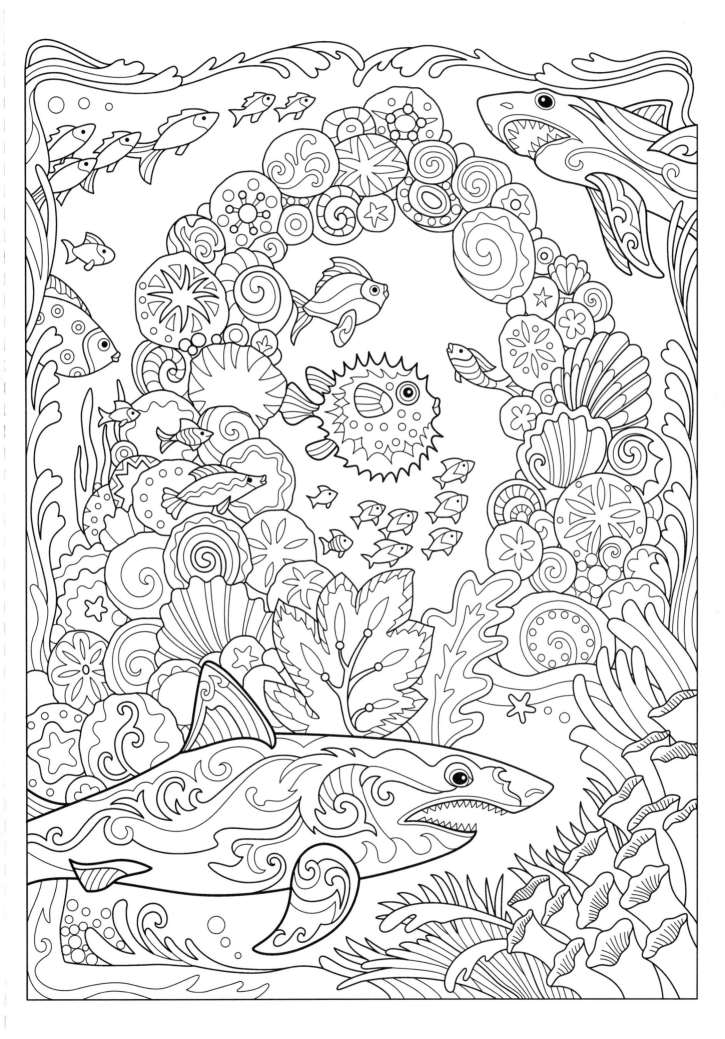

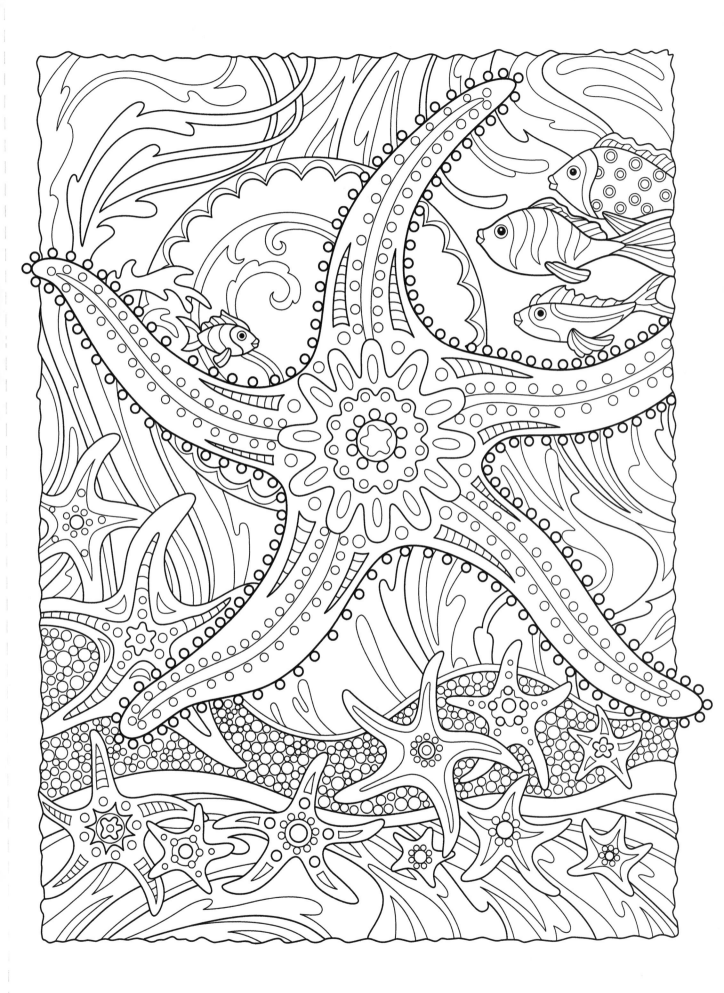

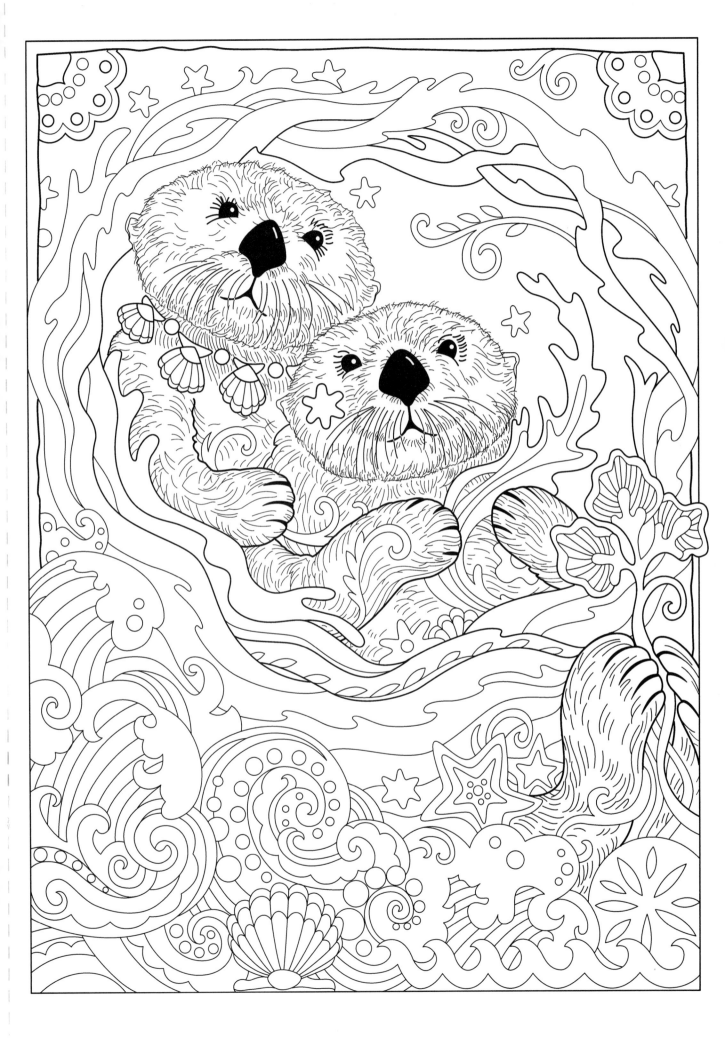

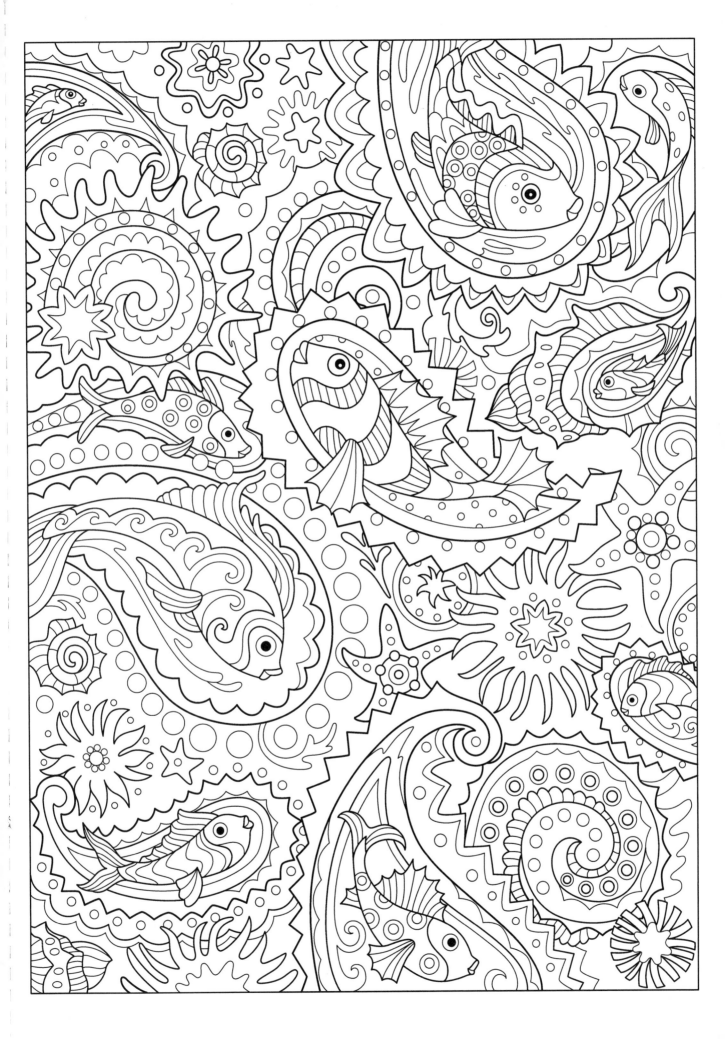

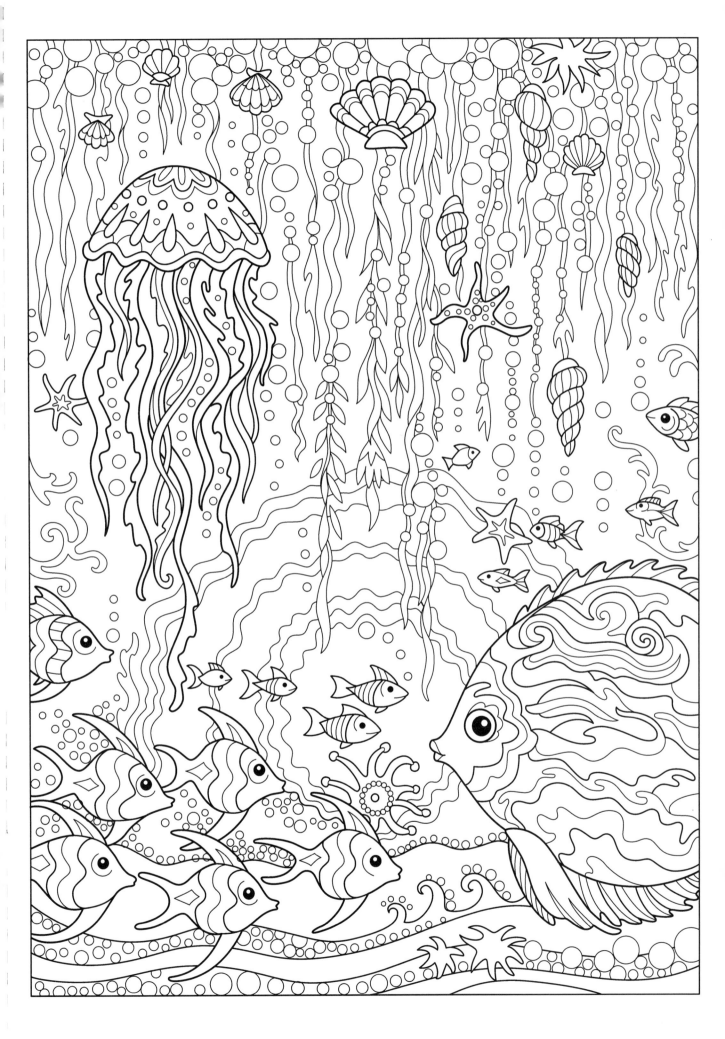

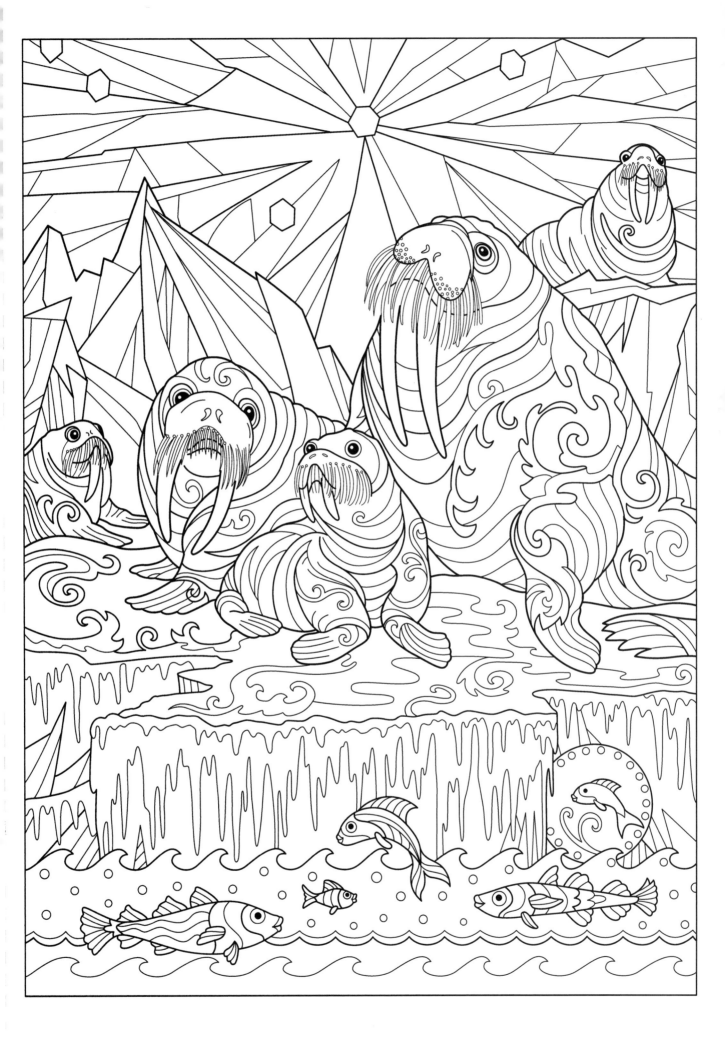

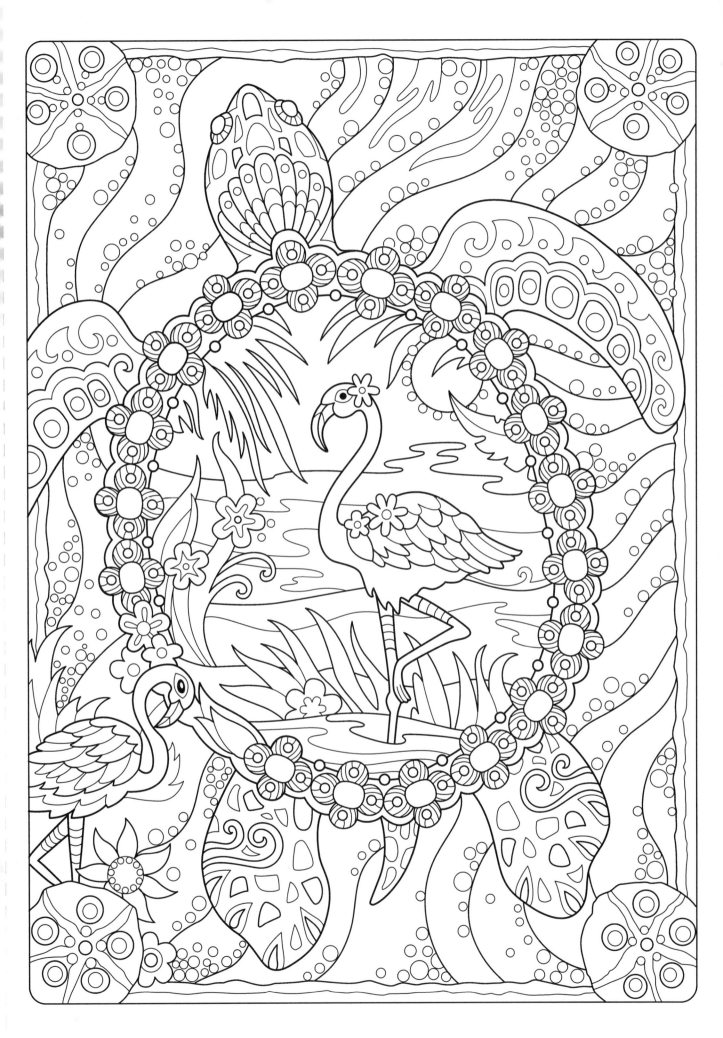

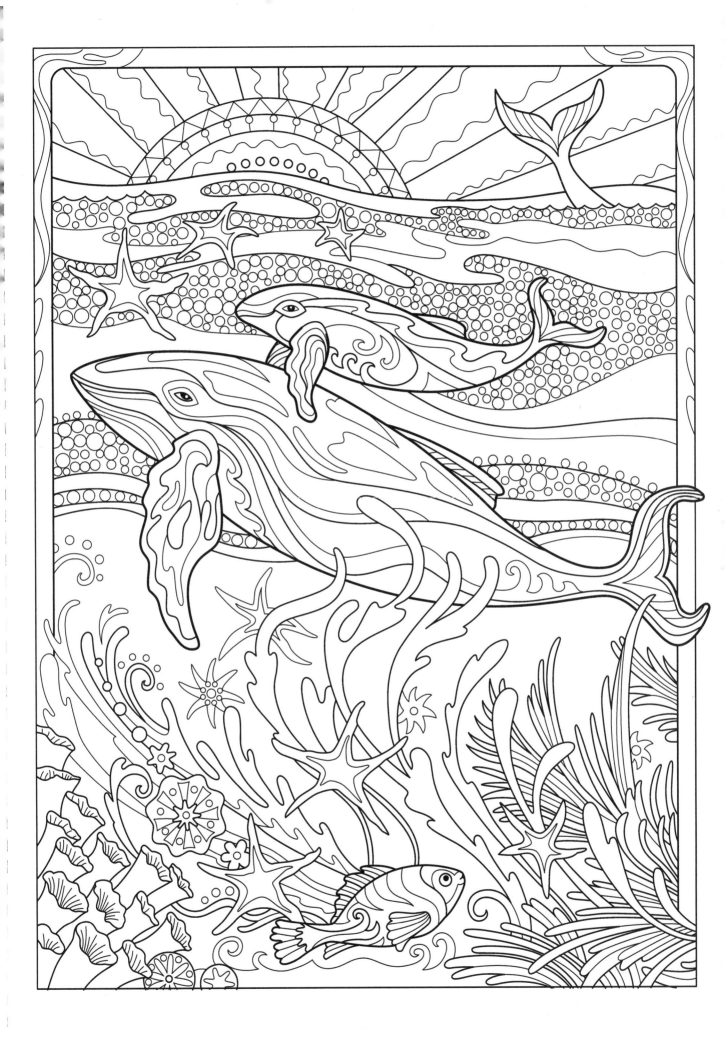